Binoca cameras, from Japan, were made to look like opera glasses and were available in red, blue, green and grey.

Cameras in Disguise

John Wade

A Shire book

Published in 2005 by Shire Publications Ltd,
Cromwell House, Church Street, Princes Risborough,
Buckinghamshire HP27 9AA, UK.
(Website: www.shirebooks.co.uk)

British Library Cataloguing in Publication Data:
Wade, John.
Cameras in disguise. – (Shire album; 449)
1. Cameras – History
2. Miniature cameras
3. Espionage – Equipment and supplies
I. Title 771.3'09
ISBN-10: 0 7478 0637 3

Cover: *(Top left) Binoca camera, resembling opera glasses; (top centre) John Player Special cigarette packet camera; (top right) Mick-a-Matic, looking like Mickey Mouse; (centre left) Stylophot, supposedly shaped like a fountain pen; (to the right of this) Watch Face Ticka, made to resemble a pocket-watch; (centre right) Transistomatic, camera and radio combined; (bottom left to centre right) Thornton Pickard Hythe Mark III, for training RAF gunners; and (bottom right) four Petie cameras, disguised as cigarette lighters.*

ACKNOWLEDGEMENTS
This book could not have been illustrated in such detail without the help of Michael Pritchard of Christie's in London, who kindly gave permission for the use of many pictures, originally photographed for Christie's catalogues. Christie's is the world's leading auction house, handling collectable and vintage cameras, movie equipment and memorabilia (for more information please visit: www.christies.com/cameras). The following photographs are © Christie's: pages 1, 3, 4, 7, 8 (top), 9 (lower two), 10 (top), 11 (top), 12, 13 (top and bottom), 16, 17 (top), 18, 19 (bottom), 20 (bottom), 23 (top), 25 (bottom), 26 (bottom), 27 (both), 28, 32 (right), 33 (bottom left and right), 34 (top), 35 (all), 36 (all), 37 (top), 47. The picture of the Thompson's Revolver Camera on page 5 is © 2005 by Auction Team Breker, Cologne, Germany. The pictures on page 41 are courtesy of The Japan Hand Made Camera Club and Isamu Mabuchi; the cameras were built by K. Hijikata, K. Kojima, K. Onozawa and K. Kikuoka. Thanks also to the following people for permission to use their pictures: John Hannavy, page 6; Bob White, page 11 (lower three), 20 (centre left); Mike Cleveland, page 13 (centre); Adrian Richmond, pages 14, 18 (top and centre); Nigel Richards, pages 10 (lower), 31; MW Classic Cameras, page 17 (lower); www.thinkgeek.com, page 44; and www.4hiddenspycameras.com, page 45. All other pictures are from the author's own collection and picture library.

Printed in Great Britain by CIT Printing Services, Press Buildings, Merlins Bridge, Haverfordwest, Pembrokeshire SA61 1XF.

Contents

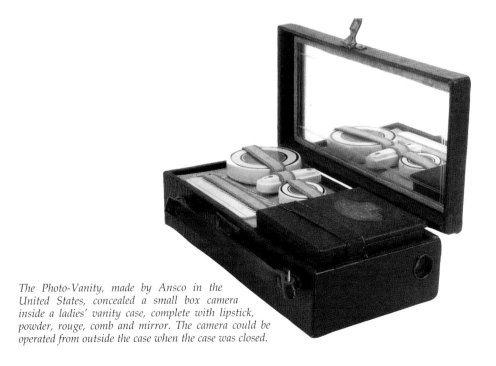

The Photo-Vanity, made by Ansco in the United States, concealed a small box camera inside a ladies' vanity case, complete with lipstick, powder, rouge, comb and mirror. The camera could be operated from outside the case when the case was closed.

Introduction

From the earliest days of photography there have been an amazing number of cameras manufactured to look like completely different objects. Here is a list of some of the items that have been known to conceal cameras: books, cravats, walking sticks, waistcoat buttons, tie-pins, parcels, belts, rings, lighters, matchboxes, cigarette packets, pocket-watches, wrist-watches, pens, hats, handbags, powder compacts, briefcases, binoculars, radios, revolvers and even machine-guns.

The earliest disguised cameras, made in the late nineteenth century and early twentieth, were produced for photographers who wanted something a little out of the ordinary, often to enable them to take candid pictures of people, as opposed to the more stilted poses that came out of the photographic studios of the day.

Later, some cameras made in the 1940s and 1950s were used in the world of espionage. But into the 1960s, when spy fiction became of more interest to the general public than spy fact, disguised cameras reverted to the novelty market and became little more than toys, before reverting to covert use with the dawn of the digital age.

The story of when, how and why so many manufacturers set out to disguise their products makes a fascinating branch of photographic history.

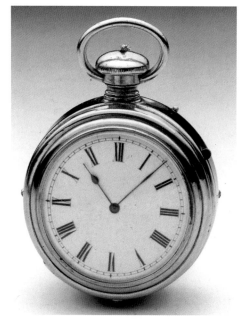

The Watchface Ticka, sold in 1912, was one of several cameras that were disguised as pocket-watches. This one differed from most models by adding a fake watch face, whose hands acted as a crude viewfinder.

The earliest disguised cameras

In January 1862 a French patent was taken out for a camera that, to some extent, resembled a revolver. The application was from an English designer named Thompson, but the camera was built by A. Brios of Paris.

Demonstrated to the Société Français de Photographie in July that year, the camera had a circular brass body containing a disc-shaped photographic plate that was rotated between exposures to take four successive pictures. A wooden gun-type handle was situated on one side of the body, while the lens, on the opposite side, resembled the barrel and was designed to slide up and down on brass tracks. Locked at the top of its throw, it lined up with a ground-glass focusing screen, covered by a magnifier in a tube on the opposite side of the body to act as a viewfinder. Then, as a catch was pressed, the lens dropped to its lower position, which lined it up with the photographic plate, and a split-second later the shutter was automatically released to shoot the picture.

Thompson's Revolver Camera, or Revolver Photographique, is generally accepted as the earliest example of a disguised camera.

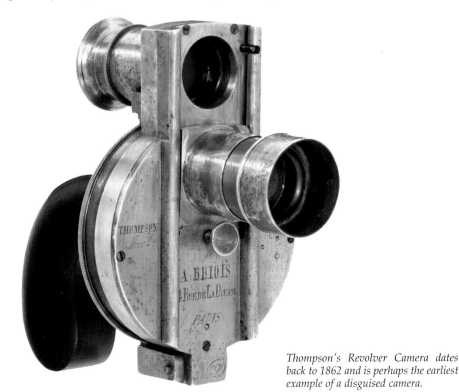

Thompson's Revolver Camera dates back to 1862 and is perhaps the earliest example of a disguised camera.

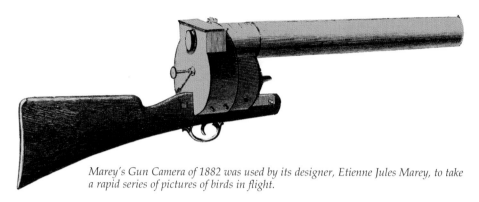

Marey's Gun Camera of 1882 was used by its designer, Etienne Jules Marey, to take a rapid series of pictures of birds in flight.

This was during photography's wet-plate era, in the days before film. Pictures were exposed on to glass plates, which were chemically prepared for the process immediately before exposure, used in the camera while still wet, then developed on the spot in a portable darkroom. It was not the ideal circumstance for a photographer endeavouring to use a camera covertly, but things were about to change. Soon wet plates gave way to dry plates, purchased ready for exposure and developed later. Cameras became easier to use, and disguised models proliferated.

One of the earliest, a Gun Camera designed by a Frenchman, Etienne Jules Marey, was produced not as a deliberate attempt at deception but more for ease of use in scientific experimentation. Marey was studying birds in flight and his camera, made in 1882, housed a long focus lens in the barrel that acted as a telescope to enlarge distant objects. A large circular dry plate was housed in a special magazine and as the gun's trigger was pressed a mechanism revolved the magazine to expose twelve pictures in rapid succession.

Another gun-type camera, the Photo-Revolver de Poche, designed by E. Enjalbert in France, appeared the following year. This one was a very realistic copy of a European gun of that time and was made using parts of a real revolver.

A model similar to Thompson's, but applied to a rifle design, under the name of Sands & Hunter Photographic Gun, arrived in 1885, while a similar design to Enjalbert's revolver camera was patented in England by a Mr Smythe. Enjalbert went on to design the Postpacket Camera, which resembled a parcel tied up with string, with the lens revealed behind a flap in the end. Models were also launched disguised as binoculars or opera glasses, with one lens for the exposure, the other for the viewfinder. Others appeared disguised as handbags, and there was even one made to look like a picnic basket.

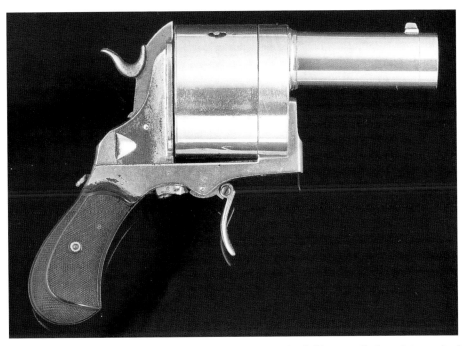

The Photo-Revolver de Poche of 1883 had a 'bullet' chamber that held ten small glass plates, each of which was pushed forward into position as the chamber was rotated. The lens was in the barrel, conventional gun sights were used as a viewfinder and the shutter was released as the trigger was pulled. It is believed that only around fourteen were made.

This was a time when detectives and their way of life were attracting increasing public interest. In the United States, Pinkerton's Detective Agency, established in 1850, was gaining in repute, while in England the first Sherlock Holmes story – *A Study in Scarlet* – was published in *Beeton's Christmas Annual* at the end of 1887. As a result, a craze for detective fiction began, together with an interest in all things covert.

Gray's Vest Camera, made in the United States at this time, took the form of a large metal disc to be worn beneath a waistcoat (or 'vest' in American parlance). The lens, situated at the top of the flat, round body, was pushed through a buttonhole, and six shots could be taken in succession on a circular plate, revolved between exposures by a knob disguised as a button. The shutter was released by pulling a piece of string that led from the camera to a convenient pocket.

In 1886 J. de Neck of Brussels came up with an idea for hiding a camera inside a man's hat. The lens looked out of the front, a viewfinder was suspended from the rim and the camera's shutter was operated by a string hanging down the side. This

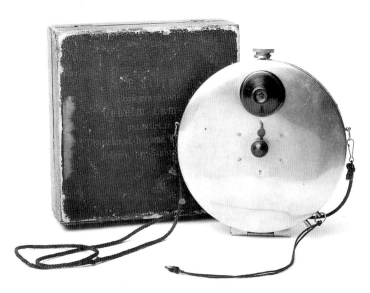

Soon after the launch of Gray's Vest Camera, the rights were purchased by C. P. Stirn, who modified it slightly before continuing manufacture of the camera shown here under the name 'C. P. Stirn's Patent Concealed Vest Camera'. The design was also copied in France.

was followed in 1890 by a design from K. F. Jekeli and J. Horner in which the lens poked through a hole in the top of the hat, which had to be removed from the head and surreptitiously aimed in the direction of the subject in order to make an exposure.

Rumour has it that John Tussaud, grandson of Madame Tussaud, used a camera hidden inside a bowler hat to secretly photograph notorious criminals on trial in court so that their likenesses could be modelled in wax for the family's famous museum.

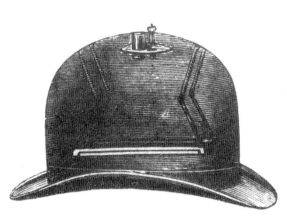

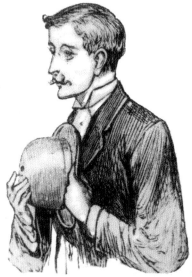

Even bowler hats were called into service to disguise cameras. This one shows the lens poking through the top of the hat, so that it had to be removed and aimed surreptitiously to shoot a picture.

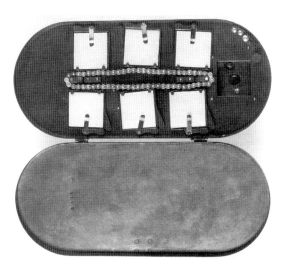

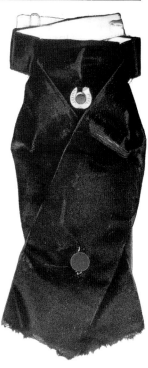

Bloch's Photo Cravate, or Detective Photo-Scarf, showing how the plate-changing mechanism worked inside, together with the way the device was advertised in 1891.

In 1890, Bloch's Photo Cravate, sometimes called the Detective Photo-Scarf, concealed a camera inside a large cravat, supplied as part of the camera, with the lens disguised as a tie-pin. Inside, the photographic plates were attached to a chain that turned to bring each into place for successive exposures.

Then there were models such as the Optimus Book Camera. Made by Perken, Son & Rayment, this was the first of several models made to resemble books, in which the 'covers' were opened to form a triangular-shaped body with the lens hidden in the spine. Better known, however, was the Taschenbuch, designed by Dr Rudolf Krügener and patented in 1888. Looking

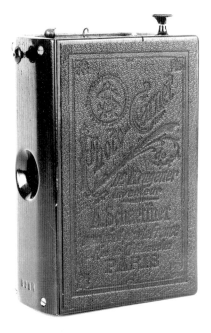

Dr Rudolf Krügener's Book Camera, made in 1888, was the most famous of several similarly styled models. (The camera illustrated is a replica.)

like a small leather-bound book, this model's lens was also located in the spine, but the 'book' did not open like its predecessors. Turning a handle pushed twenty-four plates individually from a secret compartment into place behind the lens and then on into another compartment after exposure. The camera was sold in several countries, with the book's title, engraved in the leather cover, printed in the appropriate languages.

One reason disguised cameras became so popular was because a photographer at this time, using a conventional model in a public place, would inevitably attract unwanted attention, making natural or candid photography of people almost impossible. One way around that was to use a camera such as the Facile, made in 1888 and designed as a simple mahogany box, which could be wrapped in paper to resemble a parcel. After the shutter was unobtrusively

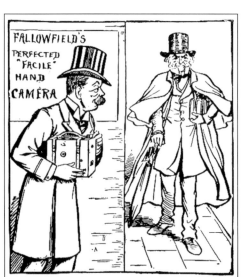

Below: *The Facile, made by Miall and sold by Jonathan Fallowfield Limited in England in 1888, took the shape of an unassuming box, easily disguised as a parcel.*

Left: *An advertisement of the time shows how the Facile could be cunningly hidden or disguised to shoot candid pictures of unsuspecting subjects.*

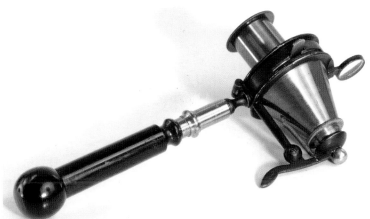

Made in London c.1891, Brin's Patent Camera doubled as a magnifying glass and opera glass. It took 25 mm diameter images on circular plates.

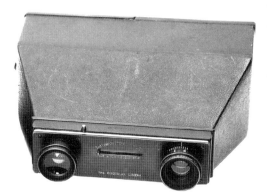

Left: *A French Photo-Jumelle camera, made by Jules Carpentier around 1892. The word 'Jumelle' in French translates as 'binoculars', which the camera resembled. One lens was used for shooting, the other as a viewfinder.*

Below: *Inside the Photo-Jumelle, showing the plate box under the taking lens. A lever was pulled from the side of the camera to change the plate.*

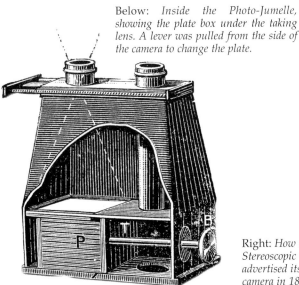

Right: *How the London Stereoscopic Company advertised its binocular camera in 1896.*

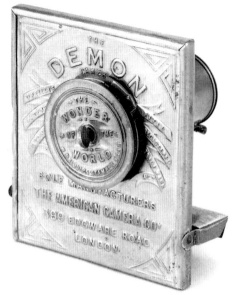

Not really disguised, but not looking very much like a conventional camera either, the Demon, made in England by the American Camera Company in 1889, took single, round exposures on dry plates. It was conical in shape with an attractive flat back on which were engraved the words 'The wonder of the world'.

tripped, a milled knob on the side shifted two grooved boxes inside so that unexposed glass plates in the top box dropped into the lower one, behind the lens, ready for shooting. In the 1890s photographer Paul Martin used a Facile, wrapped in paper and tucked under his arm, to document life in the streets of London.

In 1889 the English manufacturer Lancaster, known for quality wood and brass cameras, made a significant departure and introduced a new type of disguised camera. The original patent application of 1886 stated that it could be made in the form of a watch or chronometer case, tobacco box, matchbox, cigar or cigarette case, purse, locket or charm. The design that went into production, however, concentrated on a pocket-watch shape, in which the lens sprang out on six telescopic metal

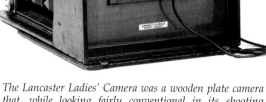

The Lancaster Ladies' Camera was a wooden plate camera that, while looking fairly conventional in its shooting position, resembled a lady's handbag when folded.

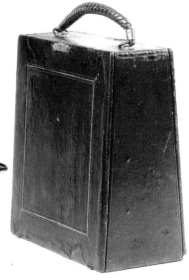

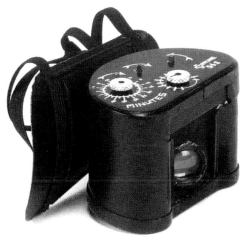

The Dopel-Sport or Pigeon Panoramic Camera was designed to be strapped to a carrier pigeon and was tested by the German Ministry of War around 1910. It is doubtful that many were made and most of those seen are replicas.

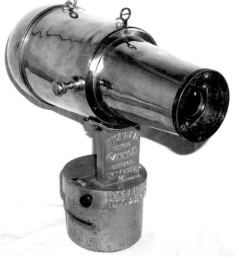

tubes as the 'watch' was opened. The back also opened to allow a small photographic plate to be inserted. The Lancaster was copied in Japan to make the Star Watch Camera in 1912.

Lancaster also introduced the Ladies' Camera in 1894, a fairly conventional design when open but resembling a lady's handbag when closed – albeit one that was made of wood. Following a similar design, the Photo Sac à Main,

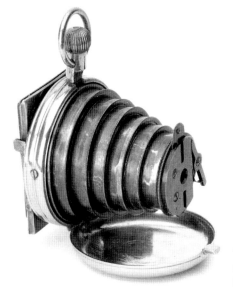

While not strictly designed as a disguised camera, the Wonder Automatic Cannon Photo Button camera did, as its name suggests, resemble a small cannon. It was made in 1910 by the Chicago Ferrotype Company for taking small, circular pictures on metal plates, which were then turned into badges – or 'buttons', as they were called in the United States.

The Lancaster Watch Camera was the first of many miniature cameras that were designed to resemble pocket-watches.

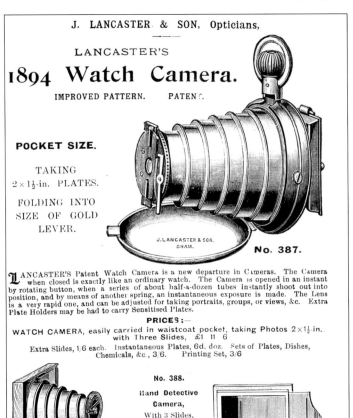

How the Lancaster Watch Camera was advertised in 1894.

made the following year by Charles Alibert in Paris, resembled a metal handbag when closed but opened to become a plate camera. Later, in 1906, the Ladies' Gem Camera, sold by Lancaster, took the handbag disguise a little further by covering the body with imitation crocodile skin and adding a chain handle.

All these were cameras designed to take glass plates. Those that followed, however, were more likely to use the latest photographic invention of the time – rollfilm.

The rollfilm revolution

Until 1888 the only truly practical method of photography used rigid glass plates for the exposures, which were generally developed by the photographer who shot them. But in that year an American former bank clerk called George Eastman introduced a camera that used rolls of film to record one hundred exposures at a time, which would then be developed and printed by his own company. It was designed to appeal not so much to dedicated photographers as to people who might not otherwise have considered owning a camera and who did not want to be bothered with developing and printing.

The camera was called the Kodak, the first time this prestigious name had been used, and it opened up the market to a new breed of camera.

Some models during this new era became known as 'detective cameras', a term that is sometimes mistakenly attributed to disguised cameras. These models were small and easy to conceal, which led to their association with detective work, but they were never meant to resemble anything other than a camera.

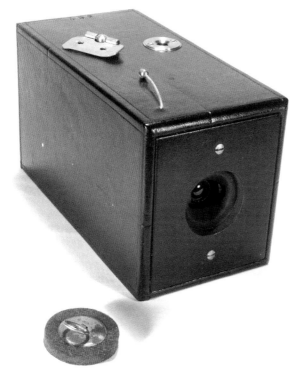

The Kodak, made in 1888, was the first commercially viable, easy-to-use rollfilm camera, which led to a new breed of disguised cameras. It could also be classed as a detective camera in its own right, since it was small and easy to conceal. (The model shown is a replica, made in 1988 to celebrate the camera's centenary.)

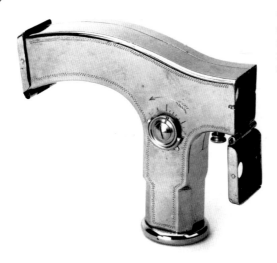

The Ben Akiba camera took the form of a walking-stick handle and could be mounted on a suitable stick to complete the illusion. The handle also incorporated storage space for three spare rolls of film.

In 1894 the Photoret hit the market, taking the shape of a watch. But unlike the Lancaster before it, this model was self-contained in the watch-type casing without the need to unfold it. Film was in the form of a circular disc that took six hexagonal pictures, 13 x 13 mm each in size.

One of the earliest disguised models to use film in a roll was the Ben Akiba Walking Stick Camera, invented by Emil Kronke in Dresden and sold in 1902. Although used as a walking stick, the camera itself was only in the handle, with a lens on its front face and a shutter release below it, easily aimed and fired by anyone using the walking stick in the conventional manner.

In 1904 the Swedish designer Magnus Niéll introduced another camera disguised as a pocket-watch. Similar to the Photoret, but made for rollfilm rather than its predecessor's film disc, it rapidly became the most popular watch-type camera of all time. The camera took a cartridge of film 17.5 mm wide and long enough for twenty-five exposures of 15 x 23 mm each. The shutter mechanism ran around the inside of the case and the lens was situated in what appeared to be the watch's winding stem, covered by a cap.

The rights to manufacture the camera in the United States went to the Expo Camera Company, which called its model the Expo Watch Camera, while in England it was made by Houghton, who called it the Ticka. In the first three months of manufacture the English company claimed ten thousand sales, and one was even made for Queen Alexandra, a keen amateur photographer. Her camera was made in solid silver, engraved with her monogram. A few other solid silver cameras were made without the monogram; there was a further version with a more sophisticated focal-plane shutter, and even a version that incorporated a fake enamelled watch face. On this, the hands stood permanently at about seven-and-a-half minutes

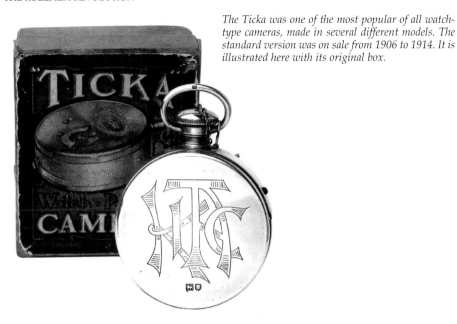

The Ticka was one of the most popular of all watch-type cameras, made in several different models. The standard version was on sale from 1906 to 1914. It is illustrated here with its original box.

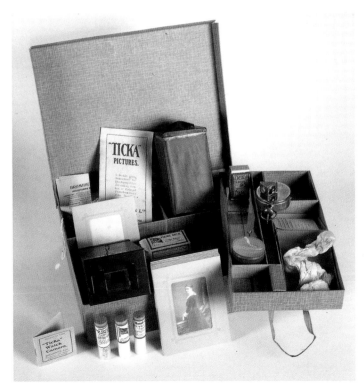

A Ticka Watch Camera outfit, including the camera, its viewfinder, film cassette, developing tray, printing box, darkroom candle lantern, three tubes of developing powder, card photoframes and instructions.

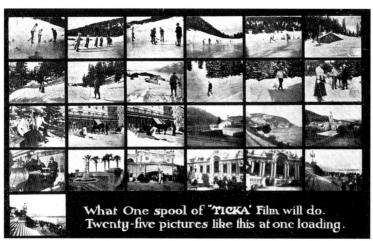

A postcard used by Houghton to advertise the picture-taking capabilities of the Ticka.

Right: This special silver Ticka was made for Queen Alexandra in 1906 and displayed her royal crest. It was subsequently passed to a member of the Royal Household and later sold by his descendants. It is now in the hands of a private collector.

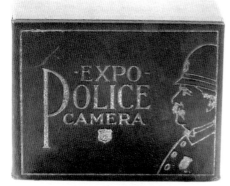

past ten to make a 'V' shape that indicated the field of view of the lens, thus forming a crude viewfinder.

Production of the Ticka in its various forms continued until the outbreak of the First World War in 1914, when Houghton shifted its focus to producing items for the war effort.

In 1915 the English company Thornton Pickard introduced the Mark III Hythe Camera, resembling a large rifle cum machine-gun. It was never meant to deceive anyone in the way of some other concealed cameras but was used instead to train Royal Air Force machine-gunners in air-to-air combat. The camera's shutter release became the gun's trigger and the resulting

The Expo Police Camera, despite showing a typical English 'bobby' on its original box, was actually made in the United States in 1911.

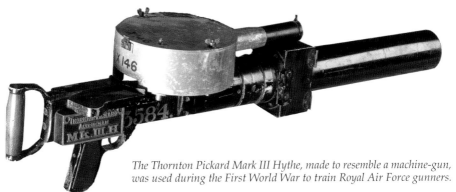

The Thornton Pickard Mark III Hythe, made to resemble a machine-gun, was used during the First World War to train Royal Air Force gunners.

pictures indicated how accurate the gunner had been in lining his sights up on the intended target.

Photography as a hobby remained popular during the war years, as soldiers took cameras such as the Vest Pocket Kodak with them into battle. But such cameras were of normal design and, by and large, the initial craze for disguised cameras that had been so popular in the late nineteenth and early twentieth century now began to wane.

After the war there was a brief resurgence of interest in disguised cameras, including such models as the Krauss Photo Revolver of 1921, which was actually less like a revolver and more like two boxes fixed together in an inverted 'L' shape. In 1928 the Talbot Invisible Camera was made to be worn under a coat and took the new 35 mm film, which had been seen for the first time only three years before with the launch of the original

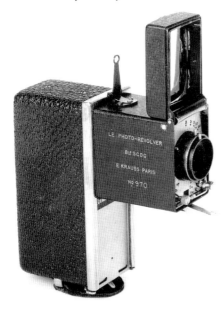

The Krauss Photo Revolver of 1921 approximated to the shape of a pistol. The large top-mounted viewfinder folded down to form a lens protector when not in use.

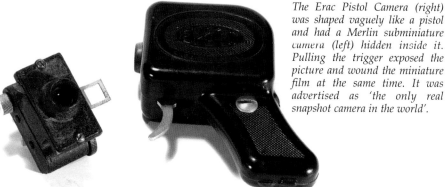

The Erac Pistol Camera (right) was shaped vaguely like a pistol and had a Merlin subminiature camera (left) hidden inside it. Pulling the trigger exposed the picture and wound the miniature film at the same time. It was advertised as 'the only real snapshot camera in the world'.

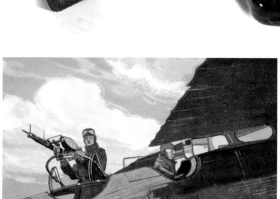

The Mitrailleuse Photographique, or Machine Gun camera, made in France by Optique et Précision de Levallous (OPL) in 1923, was used to train pilots in firing real guns in air-to-air combat. Unlike the similar English Thornton Pickard model, however, the camera was separately attached to the gun rather than being built in.

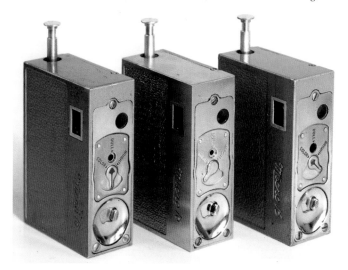

The Micro 16, made in 1946 by Whittaker in the United States, was only slightly smaller than a cigarette packet and could easily be disguised inside a standard pack. Sold in a series of colours, it could also be used as a straightforward camera in its own right.

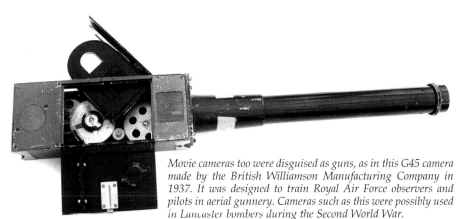

Movie cameras too were disguised as guns, as in this G45 camera made by the British Williamson Manufacturing Company in 1937. It was designed to train Royal Air Force observers and pilots in aerial gunnery. Cameras such as this were possibly used in Lancaster bombers during the Second World War.

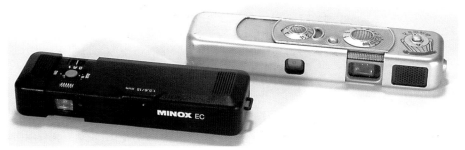

The Minox, although not disguised as any other object, was nevertheless a camera that could be easily concealed and, although made initially for general photography, it was soon adopted by intelligence services and has become the film and television world's archetypal spy camera. Pictured here are the black Minox EC, made as late as 1981, and the Minox B from 1958.

Leica camera. Following that, the Erac pistol camera appeared in 1938. Inside its Bakelite body was a smaller metal camera called the Merlin, made two years previously and incorporated into the Erac following a lack of success in its own right.

This era also saw the launch, in 1937, of the Minox, designed by a Latvian photographic dealer, Walter Zapp. Although only about the size of an index finger, the camera had a telescopic body that extended to reveal the viewfinder and uncover the lens at the same time. The action of opening and closing the body also advanced the film, which was 9.5 mm wide and contained in a tiny cartridge.

Production of the Minox in different forms continued in the years that followed and, in 1949, the execution of the American gangster James 'Mad Dog' Morelli was photographed by a *New York Daily News* photographer who smuggled a Minox camera into the execution room hidden in the heel of his boot. The picture made headline news around the world.

To the public, the Minox is probably the best-known of all spy cameras, but it was by no means the only one used in the world of espionage.

Cameras at war

The Second World War broke out in 1939 and ended in 1945. It was followed by the Cold War, a time when the Soviet Union, which had been on the side of the Allies during the initial conflict, began to exhibit ulterior motives and which the Americans, in particular, felt needed to be carefully watched. This period generated two types of clandestine photographic equipment: existing cameras, made before the war and now incorporated into other objects in order to disguise them; and cameras made specifically for spying purposes, in the shape of other everyday objects.

The Robot falls firmly into the former category. First made in Germany in 1934, it had four attributes that earmarked it for the espionage world: it could take up to fifty, slightly smaller than normal, pictures to a single loading of 35 mm film (as opposed to the usual thirty-six); its wide-angle lens provided a deeper depth of field than normal, which meant subjects could be kept sharp without the necessity for extra-accurate focusing; the especially wide field of view of the lens meant that positioning and aiming the camera was not as critical as with more conventional cameras; and it had a built-in clockwork motor-drive that automatically wound the film after each exposure.

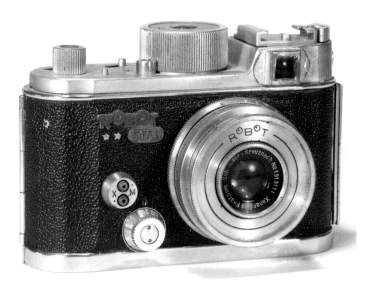

Robot cameras – this is a Robot Star from 1952 – looked conventional enough, but a clockwork film wind meant they could be operated and the film wound while concealed inside other items such as handbags, briefcases and belts.

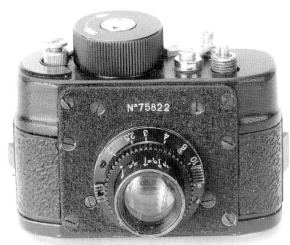

The F-21, from 1948, was adapted by the KGB from a Robot camera. It was often concealed in everyday objects or in a coat pocket.

These attributes made the Robot perfect for concealment inside some other object, from where a cable release attached to the shutter could fire and wind the film without the need for further attention from the photographer. During this period spies used Robot cameras incorporated into items that included handbags, briefcases and belts.

The Leica, first launched in 1925, was sometimes used for espionage purposes with a special lens cap in which the maker's name was cut out like a stencil. With the lens behind it, the cap looked perfectly innocent, but the camera could be used with the cap in place, as the pictures were shot through the cut-out letters of the word 'Leica'.

In 1948 the F-21 camera was adapted from the Robot by the KGB. The result was a much smaller model, no more than 77 x 41 x 55 mm, with a spring-loaded film wind. It was used concealed inside items that included umbrellas, jacket pockets and even a conventional camera case, inside which the F-21 was mounted sideways to take pictures at right angles to the way the photographer – with his closed camera case innocently hung around his neck – was facing.

Even as late as the 1960s, cameras were being hidden in this way. At 65 x 50 x 20 mm, the Tessina, made by the Swiss firm

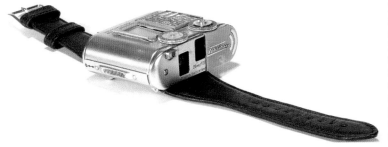

The Tessina, made in Switzerland in 1961, could be incorporated into objects such as books or cigarette packets, or worn on the wrist like a watch.

This rare Soviet KGB camera appears to have been adapted from a normal 35 mm model, shifting the lens from its usual place to the top plate at 90 degrees to the film path. It was designed to be hidden inside a business briefcase, with the lens looking through a small opening in its side. It took 35 mm film, which was wound automatically after each exposure, and the picture was taken as the handle of the case was pressed.

of Concava in 1961, was about the size and shape of a matchbox, with two lenses on the side where, if it were a matchbox, the match would be struck. Inside, two mirrors were used, one to reflect light from the main lens down to the film, which ran at right angles to it, the other to reflect light from a second lens up to a viewing screen on top of the flat body. Like the Robot before it, the Tessina incorporated a clockwork motor-drive and was used, by spies, hidden inside items such as cigarette packets and books. A wrist-strap was also available, allowing the Tessina to be attached to the arm like a wrist-watch and concealed by the user's sleeve.

16 mm movie film, which first appeared in 1923 and which was later adapted for use in still cameras in the 1930s, became an integral part of disguised cameras used by spies around the world.

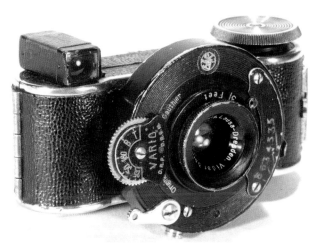

In 1932 the Mini-Fex was the first still camera to use 16 mm movie film, a style that soon led to the use of the same film in a number of spy cameras.

In the United States, Kodak's Matchbox Camera was made to be disguised by the addition of a matchbox label from any country in which it was used. It was manufactured for the American Operations Support Systems (OSS) in 1944 and was used by American and European agents as well as by members of the resistance movements in occupied Europe. The camera took thirty exposures on 16 mm film.

It was in Austria that the German Leitz company is thought to have made a matchbox camera in 1946 for use by the United States Army Counter Intelligence Corps. Other matchbox cameras were made in France.

After the Second World War the American occupying forces in Japan decreed that Japanese camera manufacturers should make equipment for military personnel and, in 1951, the Suzuki Optical Company made the Echo 8. Combining a camera with a Zippo-styled lighter, it was used by the United States Air Force in the early 1950s to gather intelligence. The Echo 8 used 16 mm

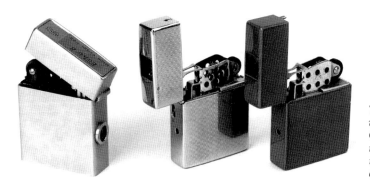

The Echo 8 and two versions of the Camera-Lite, all made in Japan to resemble Zippo cigarette lighters.

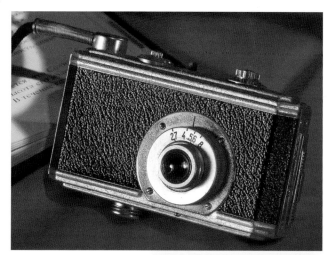

The Ufa was an unusual and rare secret service sub-miniature camera that originated in the Bashkir Autonomous Soviet Socialist Republic. It was designed to be worn under clothing with the lens poking through a buttonhole. The shutter was tripped and the film advanced by an electronic release secreted in a pocket.

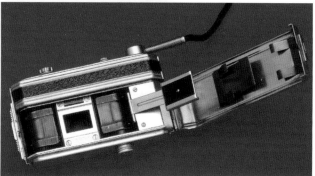

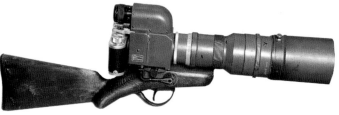

Above: *Although usually known as the Leica Gun, the camera used in this model was actually a Fed, a Soviet copy of the German-made Leica. The camera was called the Fotosniper FS-2 in the Soviet Union.*

Right: *A German camera disguised as an American matchbox. The camera itself replaced the drawer in a normal matchbox. Pushing the drawer out of the matchbox sleeve lifted a flap covering the lens and fired the shutter.*

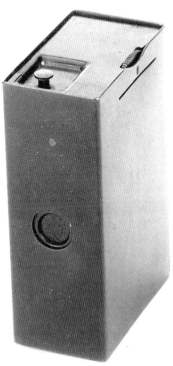

The Eastman MB, made at the end of the Second World War, was used by the American Secret Service. The camera could be disguised by slipping it into the sleeve of a matchbox.

Below: *The John Player Special was built around a Kiev 30 subminiature camera. Although sometimes sold as genuine Soviet spy cameras, many of these have turned out to be fakes made in Poland.*

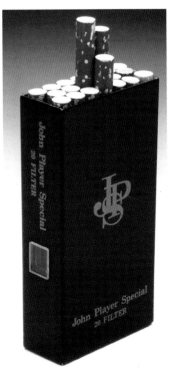

film, run through a specially supplied splitter to provide an 8 mm width, on which 5 x 8 mm pictures could be taken as its operator flipped the top and lit a cigarette. Alternatively, a waist-level viewfinder could be found under the camera's nameplate. Another plate on the body slid aside to reveal the lens as the picture was taken. An Echo 8 was used by film star Eddie Albert in the 1953 film *Roman Holiday* to photograph Audrey Hepburn surreptitiously.

In the Soviet Union, the Kiev 30 subminiature camera was disguised as a John Player Special cigarette packet, complete with false cigarettes that were actually the camera's controls. Although it was at first believed that some of these cameras were used by the KGB during the Cold War, it later came to light that many others were more likely to be fakes, made in Poland as late as the 1970s purely for the collecting market.

During the 1950s and into the 1960s microdot cameras were employed by the American Central Intelligence Agency (CIA) for, among other purposes, passing information from East to West

Germany, divided at that time by the 'Iron Curtain'. Pictures from a microdot camera, itself usually small enough to be concealed in the palm of the hand, were recorded on film as no more than a minute spot, which might then be glued to a typewritten letter, disguised as a punctuation mark, or incorporated into jewellery such as a cuff-link. The microdot and the information on it would later be read by placing it under a specialised magnifying device, many of which were also disguised as items such as cigarettes or fountain pens.

One such camera, made by Zoomar Incorporated in the United States, took 8 mm wide film (the gauge used by amateur cine cameras of the day), measured 75 x 50 x 25 mm, weighed only a little more than 2 ounces (57 grams) and had fittings for a tripod and cable release. It was made of a brittle plastic that could be easily destroyed by stepping on it or throwing it against a hard surface, should its operative be captured. The camera was never sold to the general public and, when the manufacturer closed down, the CIA ordered that any remaining cameras and their design plans be destroyed.

Perhaps the best of the real spy cameras, had it ever got past its prototype stage, would have been the Lucky Strike, made by the Mast Development Corporation of Iowa in the United States. The camera was developed for the United States Signal

The Lucky Strike cigarette-packet camera, with its associated matchbox light meter, were designed for espionage work but never went into service.

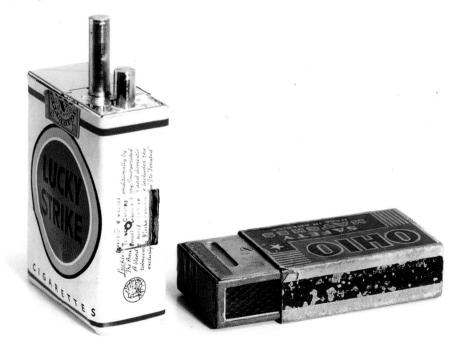

Corps and the original idea for its design was mooted in 1946. The first company approached to manufacture it fell below the initial expectations, however, so the Mast Development Corporation stepped in and the camera was developed during 1949 and 1950. The brief was for a miniature camera small enough to be concealed in a packet of cigarettes and easy to use covertly. Two designs were considered, one with manual film wind, the other with automatic wind, but the latter proved impractical.

Unlike many spy cameras, the Lucky Strike featured top-quality optics and a focal-plane shutter in front of the lens that offered variable speeds of 1/15, 1/250 and 1/500 second, plus a 'B' setting, which kept the shutter open for set times determined by the operator. It was capable of eighteen exposures at a time on 16 mm film.

The camera was the exact shape of a Lucky Strike cigarette packet but made slightly smaller so that the outer wrapping of a real packet could be taken apart and then re-glued around the camera body. Inside the packet, the actual camera had a metal matt black body with a chrome top. Its lens was positioned on one side, behind a suitable aperture in the side of the cigarette packet, camouflaged by a second shutter.

The camera's main controls were in the form of three false cigarettes, which extended from the top of the 'packet'. One wound the film, the second controlled the apertures and the third focused the lens. The shutter speeds were changed by

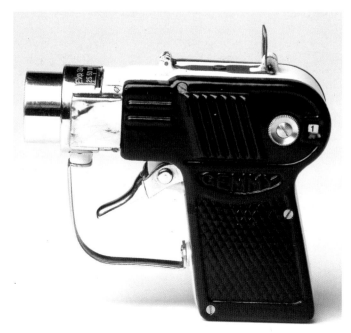

The rare Mamiya Pistol Camera from 1954 is said to have been used in Japan for police training. It took half-frame size images on 35 mm film, and it is believed that only 250 were made.

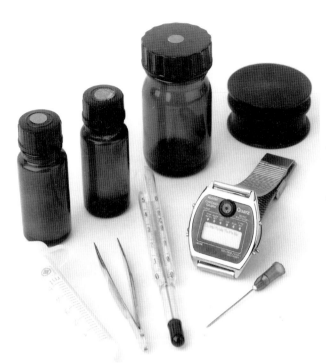

This digital wrist-watch, combined with a camera, was available in England during the 1980s and distributed by P3 Personal Protection Products. Film, which was available from the distributors, was in the form of tiny discs. The camera was sold complete with chemicals for processing the film, a thermometer, tweezers and a syringe for injecting and sucking out the chemicals from a supplied developing box.

minute buttons on the camera body that could be felt and operated through the packet's wrapping.

The Lucky Strike camera was originally designed to be used with its own separate exposure meter, manufactured by the Quavas Corporation and made to resemble a matchbox.

Although the Lucky Strike was capable of good-quality pictures, there is no evidence to show that it was ever adopted by the United States army, and only two models are known now to exist, one of which was a development model, the other

The Minimax, made in 1981 by Nikoh in Japan, resembled a butane cigarette lighter. Inside was a subminiature camera that took Minox film.

The Tochka 58M was a Russian camera designed to be worn behind a special tie, with the lens disguised as a tie-pin. With its built-in clockwork motor, it took up to twenty exposures before being rewound.

used for test purposes. One of these cameras is now in the United States Army Signal Corps Museum in New Jersey; the other is in the hands of a private collector.

Of course espionage was not the sole prerogative of the Americans. In the Soviet Union, cameras were made for the purpose as late as the 1980s. Perhaps the most notable from this era is the Tochka 58M (sometimes referred to as the 'Toyca' because that is the way the name looks in Cyrillic script).

The Tochka was a subminiature, measuring only 83 x 28 x 20 mm. It took Minox size film in a tiny cassette and was sold with a film-splitting device that cut two 9.5 mm wide strips from the centre of a normal 35 mm film. Unlike the Minox, its lens was positioned at right angles to the film plane, its image reflected on to the film via a 45 degree mirror. The camera was designed to be worn in a harness attached to the body, its lens in the centre of the tie-pin of a specially adapted tie. A remote release, concealed in the wearer's pocket, controlled selection of the appropriate shutter speed and released the shutter before a clockwork motor automatically advanced the film for the next exposure.

The Tochka was a highly sophisticated little instrument with definite espionage connections, but it was among the last of its type. Many of the disguised cameras that followed were more likely to fall into the novelty bracket.

Novelties and toys

In 1947, in occupied Japan, a camera was made that was eventually listed in the *Guinness Book of Records* as the world's smallest production camera. Made in both round and hexagonal shapes, it was called the Petal. Although the Petal was not disguised in the way that some other cameras were, it did slightly resemble a small pocket-watch, and its minuscule size – little more than one inch (25 mm) in diameter – meant it could be easily hidden and used covertly.

The Petal came at the start of a new age in camera design, when many manufacturers made disguised cameras, not for any practical purpose but simply to prove it was possible.

The German Steineck ABC, launched in 1948, is a typical example. There is no real evidence to show it was ever used for genuine espionage purposes but, nevertheless, here was a camera made to resemble a man's wrist-watch. It took eight exposures, each one 6 mm wide, on a 25 mm diameter disc of film. A special punch was supplied to make the disc blanks from standard 35 mm film.

The 1950s were a time when low-quality subminiature cameras, using 16 mm rollfilm, proliferated. The Petie, like most of them, resembled a small,

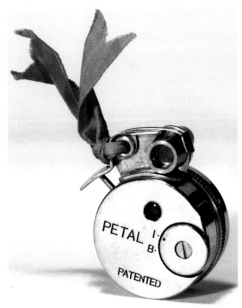

Above: *At one inch (25 mm) in diameter, the Petal, made in Japan in 1947, was reckoned to be the world's smallest production-made camera. It was easily concealed for clandestine photography, but the size of its tiny images guaranteed that the result would be of low quality. All Petal cameras were sold with a red ribbon; its purpose was apparently purely decorative.*

Although probably never used for true espionage work, the Steineck ABC, from 1948, was made to look very like a man's wrist-watch.

scaled-down version of a normal camera. But in 1956, when it was launched, it was also disguised by incorporating it into a beautifully crafted Art Deco style ladies' compact, complete with mirror, face-powder compartment, lipstick and space for a spare roll of film. This model was known as the Petie Vanity. The same camera was also built into a cigarette lighter.

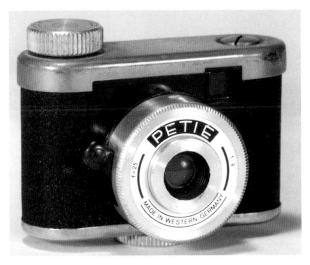

The Petie was a subminiature camera made for 16 mm rollfilm in 1956. But the camera was also adapted for use in several disguised versions, including as a ladies' powder compact and a cigarette lighter, each of which was available in different colours.

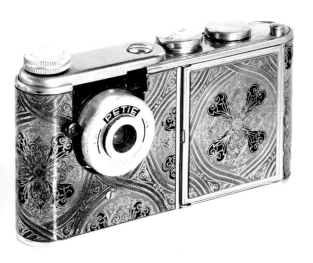 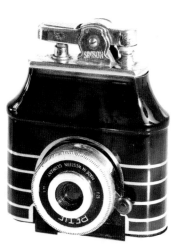

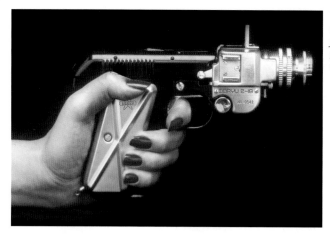

The Japanese Doryu, made in the 1950s, could have passed for an extremely convincing gun It even took flash cartridges shaped like bullets.

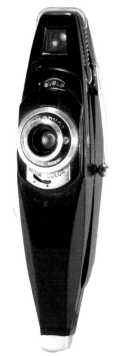

Left: *The Stylophot took 16 mm film and was supposed to look like a pen, though it is unlikely that it fooled many people.*

The Doryu, made in Japan in the mid 1950s, revived the old idea of disguising a camera as a gun – an extremely convincing automatic pistol, with the camera built into the barrel and an interchangeable lens that could be swapped with most normal 16 mm cine lenses. For flash photography, small, bullet-like cartridges, containing magnesium flash powder and an igniting chemical, were loaded into the butt just like the real thing. Pulling the trigger shot one frame of film, a striker ignited the flash powder and the spent cartridge was ejected. The picture size was 10 x 10 mm.

In the same decade cameras were also disguised as pens, although being long and slim with an attached pocket clip was about as close as they got to any real resemblance. Taking the 16 mm film that had by then become synonymous with subminiature cameras, they included several designs by the French company Secam under the Stylophot name, plus another from Japan called the Septon Pen Camera, whose resemblance was actually closer to a propelling pencil.

Several cameras, of varying quality, made to resemble binoculars or opera glasses, were also introduced in the 1950s.

The German-made Cambinox used a real pair of binoculars and mated them to a 16 mm camera, whose lens was mounted between the two normal lenses. The camera lens was a telephoto design, producing an image of the same magnification as that of the binocular lenses. It was also

The Speccam, made in the 1950s, was a large tabletop lighter that incorporated a Minox camera.

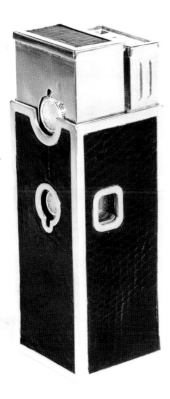

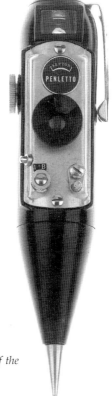

The Penletto, from Japan in 1953, is one of the lesser-known pen cameras.

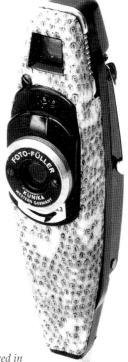

The Foto-Fuller Luxus was a pen camera similar to the Stylophot but covered in simulated snakeskin.

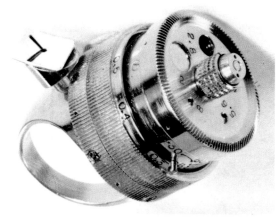

The GF-81 ring camera was made in Italy by Gian Paulo Ferro in a very limited production run. One of the smallest cameras ever made, it nevertheless featured shutter speeds from 1/30 to 1/500 second and a focusing lens. A film punch was supplied to stamp out the necessary discs of film from standard 35 mm, and a miniature developing tank was also available.

The Warsavie ring camera's origins are unclear but may have been based in Warsaw. It was smaller and slightly less conspicuous than the Italian GF-81.

interchangeable with two other lenses, one that shot a wider angle and a second that produced an even greater magnification than the viewing lenses.

The Japanese Nicnon company attached a Ricoh camera, complete with clockwork motor-drive, to the side of one of the

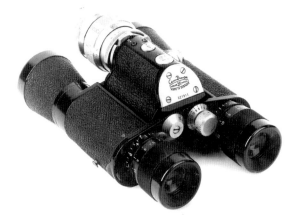

The Cambinox added a 16 mm camera to a pair of real binoculars. It offered interchangeable lenses, which was unusual in models of this type.

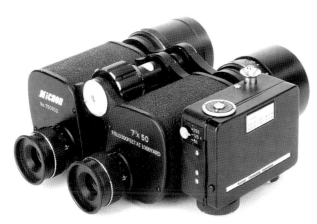

The Nicnon took the form of a pair of binoculars with a small, half-frame camera incorporated on one side.

binocular lenses and shot its 18 x 24 mm images on 35 mm film via a semi-silvered mirror in the right-hand lens. This special mirror allowed some light through the lens to the binocular eyepiece while reflecting the rest through 90 degrees to the film.

The Cyclops and Teleca, made in Japan in 1950, were name variants of the same model. They took a small pair of opera glasses and added on top a 16 mm camera with a telephoto lens that matched their field of view and took images of 10 x 24 mm.

The problem that plagued cameras of this type was camera shake. It is a problem that is exaggerated by telephoto lenses but can be cured by the use of fast shutter speeds, which, in turn, need to be coupled with wide-aperture lenses. The Cambinox and Nicnon allowed for this and so were capable of very good images. The Cyclops and Teleca, although beautifully made, were a lot less successful.

Towards the end of the 1950s and into the 1960s, radio technology underwent a revolution as transistors replaced

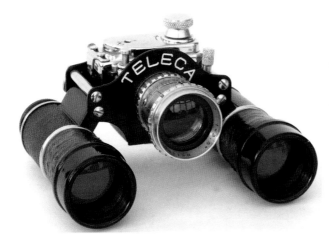

The Teleca mated opera glasses with a 16 mm camera. Both the camera lens and the opera-glass lenses could be focused by the user and the camera had a range of apertures plus three shutter speeds. It was a beautifully crafted piece of equipment, but even the top shutter speed of 1/100 second would not have prevented camera shake when hand-held, which is why it also incorporated a bush for screwing to a tripod.

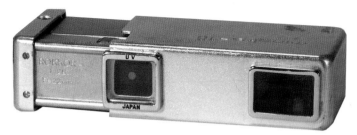

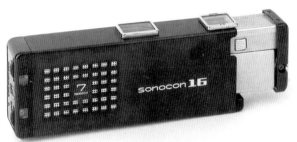

The Minolta 16 camera was the basis for the same company's Sonocon 16, one of several cameras that were combined with radios.

valves, leading to smaller, portable radios, and it was not long before cameras began to be built into them. Among them was a camera from Japan made under two names whose derivations are not difficult to understand; they were the Ramera and the Kamra. Other radio cameras included the Transistomatic and the Tom Thumb.

In the 1960s there emerged a developing interest in the world of espionage, partly because of the real-life spy cases prevalent

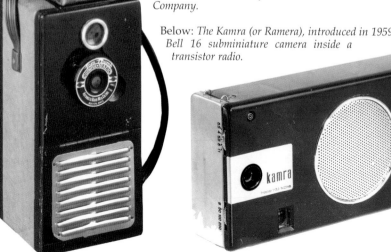

Left: *The Tom Thumb radio camera, made in the United States around 1948, was a simple plastic reflex camera combined with an old valve radio. It was made by the Automatic Radio Manufacturing Company.*

Below: *The Kamra (or Ramera), introduced in 1959, hid a Kowa Bell 16 subminiature camera inside a transistor radio.*

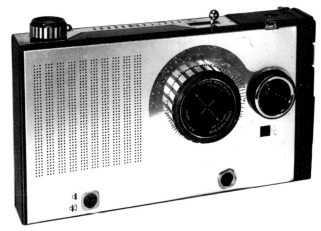

The Transistomatic, made by GEC in 1964, combined a Kodak Instamatic camera (first launched the previous year) with a radio.

in the news at the time. The British intelligence officer Kim Philby became one of the most famous spies of the twentieth century when he defected to the Soviet Union in 1963. Other real-life spies included Guy Burgess, Donald Maclean and Anthony Blunt, who all became household names, and in the world of fiction James Bond – no stranger to spy cameras – made his film debut in *Doctor No* during 1962. All of this fuelled interest in undercover operations and associated equipment.

In 1963 Kodak introduced a new photographic system that not only revolutionised snapshot photography but also opened the door to a new breed of disguised camera. At this time photography was a major hobby whose only stumbling block for many was the difficulty of loading a camera. Kodak changed all that with the Instamatic system, which introduced film (known as 126 size) in a pre-loaded cartridge that was simply dropped into the camera back.

Two of the more unusual cameras to use the system were the Mick-a-Matic, made in the shape of Mickey Mouse's head, with the lens hidden in his nose, and the Snoopy-Matic, which was shaped like a dog kennel and

Cartoon characters used in novelty camera design included Snoopy from the 'Peanuts' comic strip, Charlie Tuna and Donald Duck.

Action Man gets in on the act with a 110 film camera hidden in his chest.

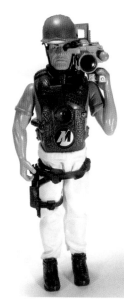

had the cartoon character Snoopy lying across the roof. Both were made in the United States.

With the success of 126 Instamatic cameras assured, Kodak followed up in 1972 with the Pocket Instamatic system, which took the same idea and translated it into smaller film in a smaller cartridge. The film (known as 110 size) was actually 16 mm, the same size as that used in many of the true spy cameras of the past.

This 110 size film sparked off a series of novelty cameras that were disguised as objects such as drinks cans, model aeroplanes, car tyres, books, binoculars, several types of cigarette packet, bags of McDonald's fries, and faces that

Below: A range of models that took advantage of Kodak's Pocket Instamatic System, allowing small cameras to be disguised as cigarette packets, books, tyres, drinks cans, a miniature jumbo jet and even a bag of McDonald's fries.

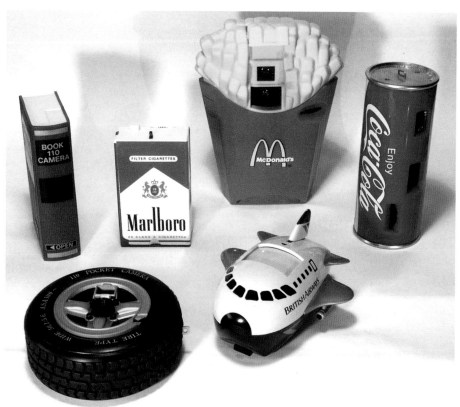

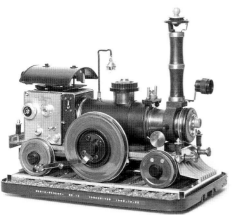

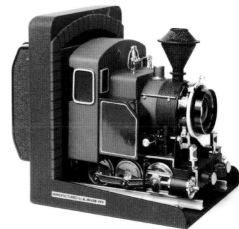

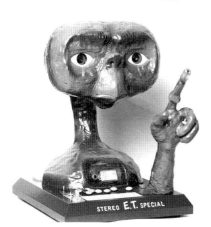

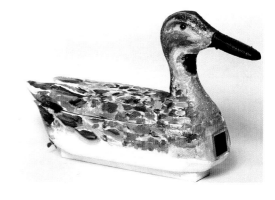

The Japan Hand Made Camera Club was formed in 1971 and has a membership of around fifty, dedicated to building their own cameras, many of which are disguised models. Shown here are: a steam locomotive, in which the cab is made from a 1936 Primarflex; Thomas the Tank Engine, which slides back and forth on rails to focus the lens; a radio-controlled Duck Camera that can swim among real ducks and shoot pictures at the same time; an ET camera that takes stereo pictures through the eyes when his finger is touched; and a Cannon camera whose body is made from a 1975 Soviet Kiev 80 camera.

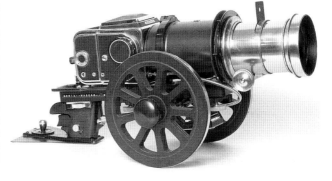

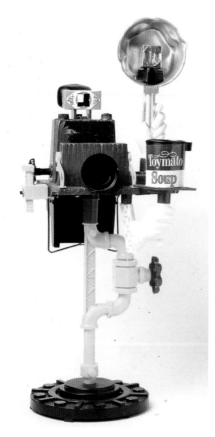

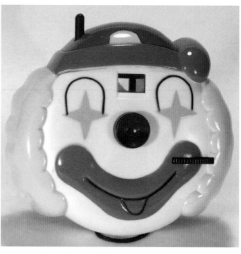

Above: *The Clown Girl camera, made in the 1990s for 110 size film, was the last in a series of similar models based on faces that included a male clown, a bear, a panda and Santa Claus.*

Left: *The aptly named Kookie, made by the American Ideal Toy Company in 1968, used an anamorphic lens purposely to distort images. Immediately after exposure, the film could be developed in a tank fitted below the camera. A built-in egg-timer was used for timing development.*

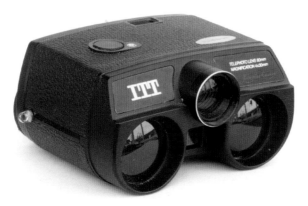

The Binocular Camera, made in Japan, built a 110 film snapshot camera into a pair of low-powered binoculars. It was among the last of the film cameras to adopt this particular disguise.

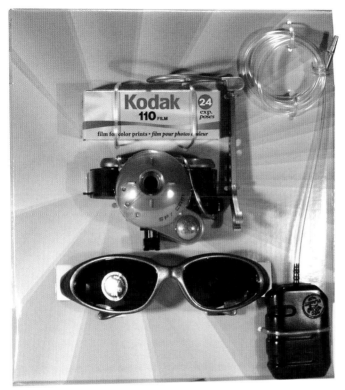

Made in China in 2004 and no more than a toy, this rather unconvincing Spy Camera was designed for children aged six and above, to be attached to a pair of sunglasses. The shutter was released remotely by a squeezing a bulb that blew air through a plastic tube.

included clowns, bears and Father Christmas. There was even a special edition of Action Man with a tiny model of a video camera on his shoulder and a real 110 film camera hidden in his chest.

As disguised cameras became little more than toys, it looked like the end of an era – but the craze did not end there. A new technology was soon to emerge that revolutionised all types of camera design, including disguised models.

Digital disguises

The age of digital photography began in 1982 when Sony demonstrated a prototype camera called the Mavica, an abbreviation of the words 'magnetic video camera'. That early version of the Mavica never came on to the market and it fell to Canon, in 1989, to introduce the first commercial still-video camera, calling it the ION, short for 'Image Online Network'.

It was ten years or more before digital cameras, both still and movie, began to make serious inroads into the camera market, but when it happened disguised cameras made a significant comeback.

Companies emerged, especially in the United States, whose speciality was building digital still and movie cameras into almost any object, including radios, cellphones, pens, clocks, sunglasses and even teddy bears. While some of these were designed to be used in the home – for watching babies or elderly relatives, for example – many more were designed for more sinister reasons.

Over the years, with the exception of a handful of cameras made in and around the end of the Second World War, the majority of disguised cameras were designed more as novelties or as unusual variants on the traditional camera shape than for genuinely covert purposes. But with the advent of digital technology, disguised cameras began to find their way into the workplace, to keep a covert watch on employees, or for industrial espionage.

Nearly 150 years after the first disguised cameras appeared, the new variants on this old theme finally found their true vocation.

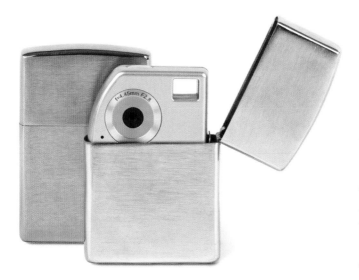

How disguised cameras have made it into the modern digital world. This is a JB1 ('JB' for James Bond), a digital and video camera with voice recorder and integral hard disc, all built into a Zippo-style cigarette lighter.

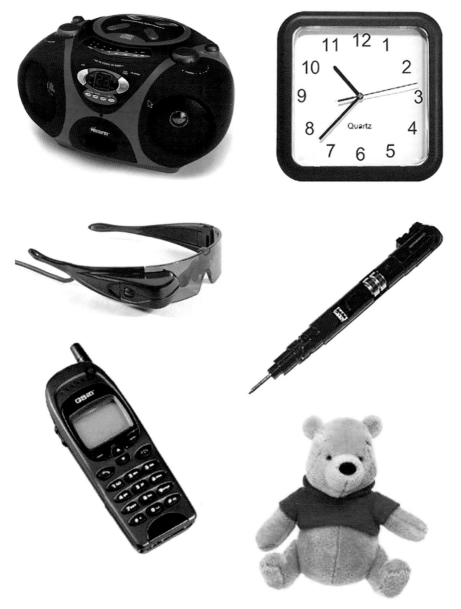

Just some of the ways in which one modern American specialist company is disguising the latest digital cameras for domestic and industrial use.

Further information

Books

Coe, Brian. *Cameras from Daguerreotypes to Instant Pictures*. Marshall Cavendish, 1978. A complete history of the camera, with a chapter on disguised cameras. Out of print, but worth seeking out second-hand.

Moses, Morris, and Wade, John. *Spycamera – the Minox Story*. Hove Collectors Books, 1998. A history of the camera that has for so long been associated with spies, both factual and fictional.

Pritchard, Michael, and St Denny, Douglas. *Spy Camera*. Classic Collection Publications, 1993. A well-illustrated account of many subminiature cameras, including disguised models.

Wade, John. *The Collector's Guide to Classic Cameras 1945–1985*. Hove Books, 2001. Devoted mainly to collecting post-war cameras, but briefly mentions disguised models.

White, Robert. *Discovering Old Cameras 1839–1939*. Shire, third edition 1995, reprinted 2001. Covers all types of camera from the first hundred years of photography.

Club

The Photographic Collectors Club of Great Britain. One of the world's foremost clubs for camera collectors, holding regular meetings throughout the United Kingdom and publishing a glossy quarterly magazine, regular newsletters and postal auctions. Contact the membership secretary at 5 Buntingford Road, Puckeridge, Ware, Hertfordshire SG11 1RT. Telephone: 01920 821611.

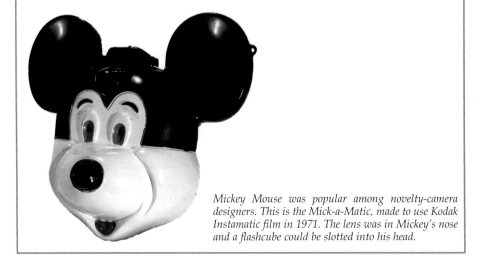

Mickey Mouse was popular among novelty-camera designers. This is the Mick-a-Matic, made to use Kodak Instamatic film in 1971. The lens was in Mickey's nose and a flashcube could be slotted into his head.

Places to visit

Imperial War Museum, Lambeth Road, London SE1 6HZ. Telephone: 020 7416 5320. Website: www.iwm.org.uk Contains a small selection of spy cameras used for wartime espionage purposes.

Life In A Lens, 118 North Parade, Matlock Bath, Derbyshire DE4 3NS. Telephone: 01629 583325. Website: www.lifeinalens.co.uk Privately owned museum that traces the complete history of photography in various themed rooms.

The National Museum of Photography, Film and Television, Pictureville, Bradford, West Yorkshire BD1 1NQ. Telephone: 01274 202030. Website: www.nmpft.org.uk This is the largest British museum of its kind.

The Science Museum, Exhibition Road, South Kensington, London SW7 2DD. Telephone: 0870 870 4868. Website: www.sciencemuseum.org.uk Covers all sciences, including a gallery on early photographic equipment.

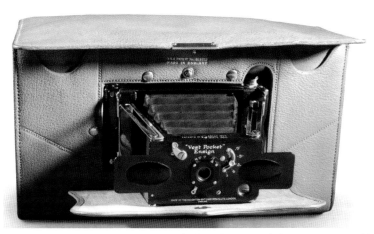

The Vest Pocket Ensign, made in 1926, was a fairly ordinary English camera. But in this ultra-rare version the camera is hidden inside a handbag. It was the subject of British and American patents in 1926 and 1928. Only five examples are known to exist.

Index